The 47 Ronin

A STORY OF SAMURAI LOYALTY AND COURAGE

BARRY TILL

Pomegranate

SAN FRANCISCO

Published by Pomegranate Communications, Inc.
Box 808022, Petaluma CA 94975
800 227 1428; www.pomegranate.com

Pomegranate Europe Ltd.
Unit 1, Heathcote Business Centre
Hurlbutt Road, Warwick
Warwickshire CV34 6TD, UK
[+44] 0 1926 430111

Library of Congress Cataloging-in-Publication Data
Till, Barry, 1951–
 The 47 ronin : a story of samurai loyalty and courage / Barry Till.
 p. cm.
 Summary: Relates the true story of masterless samurai (ronin) who avenged their lord's death and came to represent the ultimate ideal of self-sacrifice.
 ISBN 0-7649-3209-8 (alk. paper)
 1. Japan–xHistory—Aka Vendetta, 1703. 2. Forty-seven Ronin. I. Title: Forty-seven ronin. II. Title.

DS873.T55 2005
952'.025'088355—dc22

2004060028

Pomegranate Catalog No. A770

Design by Lynn Bell, Monroe Street Studios, Santa Rosa, California

Cover image: Act XI. Fifth Episode. Ronin being stopped and prevented from crossing Ryogoku Bridge.

Printed in China

14 13 12 11 10 09 08 07 06 05 10 9 8 7 6 5 4 3 2 1

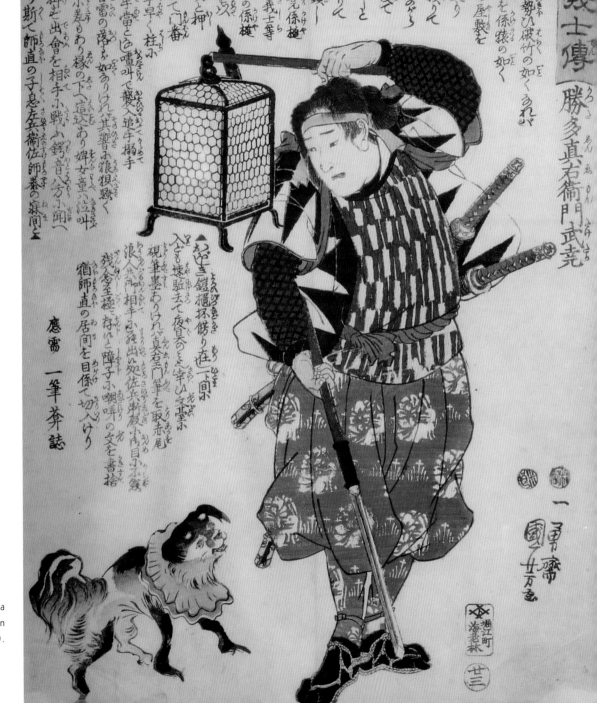

Detail of Katta
Shinemon
(see page 74).

Bushido

THE WAY OF THE WARRIOR

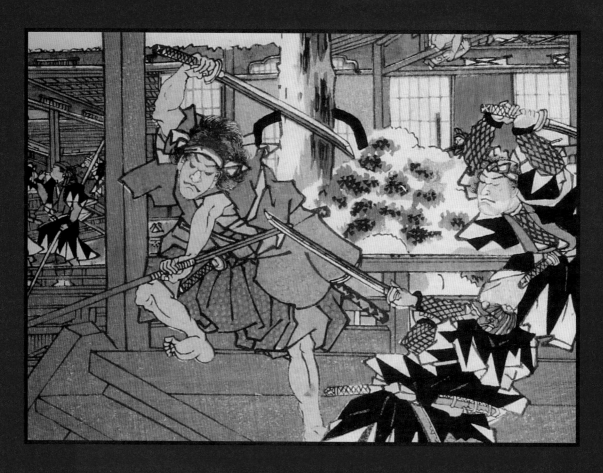

At the turn of the eighteenth century, Japan was a feudal state ruled by a figurehead emperor and a much more powerful *shogun,* or military governor. The shogun commanded the allegiance of the nation's *daimyo*—feudal lords— and each daimyo had his own private army of "loyal retainers" to steadfastly protect his interests. These private warriors were the *samurai.*

Japan's samurai class lived by an ethical code known as *bushido* ("the way of the warrior"). Derived in large part from Chinese Confucianism, bushido was based on the principles of *chugi* (loyalty) and *giri* (moral obligation or duty)—first to the daimyo, then to family and society.

Each samurai had to attain a high degree of self-control, learning not to display the slightest emotion, whether it be joy, fear, or sorrow. The samurai's life was directed by righteousness. He was not to disgrace his status, he had to live up to the honor and specific obligations expected of him, and he had to lead a life of frugality and discipline.

The samurai also had to develop a freedom from fear of death. He often compared himself to the delicate cherry blossom, a beautiful but perishable flower that falls at the slightest breeze. So, too, the samurai was expected to meet his death without trepidation; he had to be willing to sacrifice himself and his family, if need be, for the cause of his daimyo.

After loyalty to one's lord, the second most important ideal of the samurai was martial bravery. He despised cowardice, choosing never to show his back to the enemy in battle, and sought glory through his military skills and his honor as a warrior and a descendant of warriors. In ancient times, before going into battle, rival armies were expected to send out their great warriors to meet and face each other in individual combat. In time, however, tactics changed, and this tradition began to disappear.

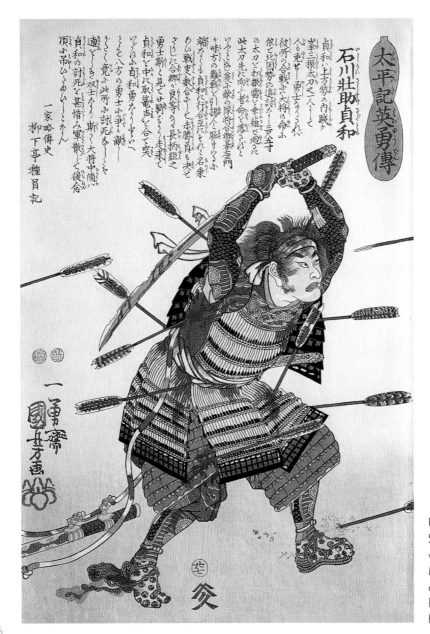

6

Utagawa Kuniyoshi (1798–1861)
Series: *Heroes of the Taiheiki,*
woodblock print. Gift of
Mrs. C. D. Moffatt, Art Gallery
of Greater Victoria, 86.27.3
Ishikawa Sosuke Sadatomo
fighting to the death.

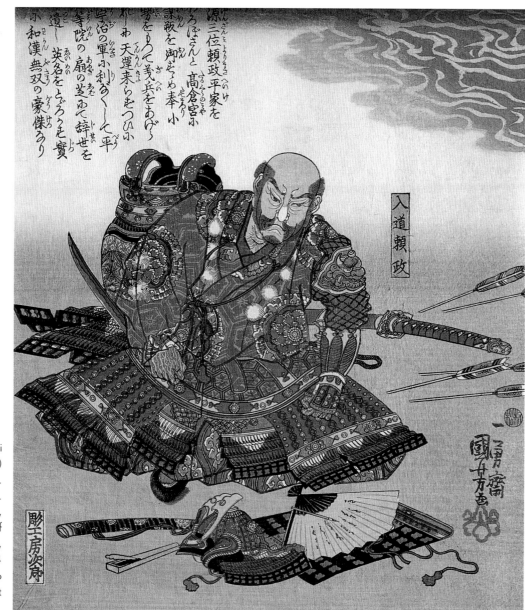

源三位頼政平家を

ほろぼさんと高倉宮小

謀叛を御そゝめ奉り小

勢をもつて義兵をあげ～

天運来らずつひに小

宇治の軍小利るく～て平

等院の扇の芝ふて辞世を

遺し～英名をとゞろを社實

小和漢無双の豪傑なり

入道頼政

Utagawa Kuniyoshi
(1798–1861)
Woodblock print.
Gift of Mr. & Mrs.
William Hepler,
Art Gallery of
Greater Victoria,
92.39.4
Yorimasa Minamoto
about to commit
seppuku (suicide).

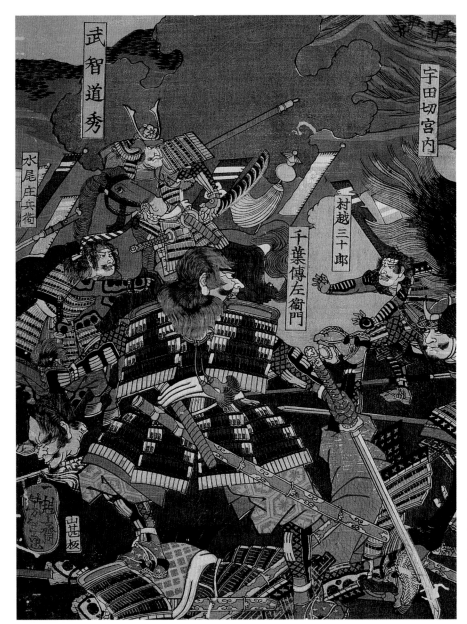

Taiso Yoshitoshi
(1839–1892)
Woodblock print.
Gift of Mr. & Mrs. J. L.
Minnis, Art Gallery of
Greater Victoria, 96.6.3
Denzaemon Chiba
carrying severed head.

8

In battle, the samurai preferred death to capture, which he considered dishonorable. If he was wounded or badly outnumbered, he was expected to commit suicide with his sword or dirk by the painful disembowelment method called *seppuku* (commonly known in the West by its vulgar term, *hara-kiri*). This method involved slicing the abdomen crosswise from left to right, followed by a slight cut upward at the end. (The abdomen was considered the center of one's being, where the soul, spirit, will, and emotions were found.) Later, at an agreed time, the samurai's assistant would behead the fallen warrior. Seppuku was considered courageous and honorable—even beautiful—and only members of the samurai were permitted the honor of such a death.

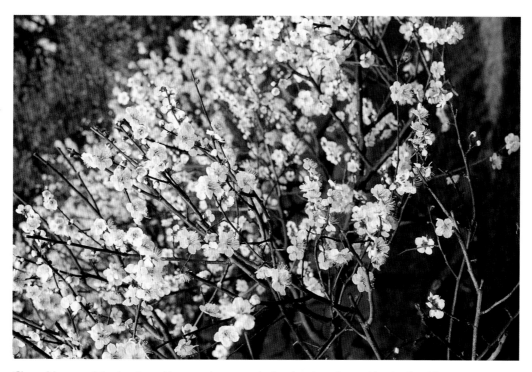

Cherry blossoms. Like the cherry blossom, the samurai had a short but glorious life. As the delicate cherry blossoms fall at the slightest breeze, so, too, does the samurai meet his tragic death without trepidation.

The Story of the 47 Ronin

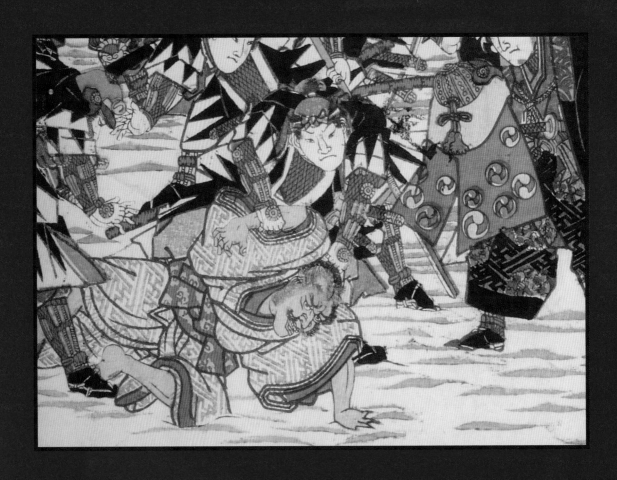

*T*HIS CLASSIC SAGA—A TRUE STORY—IS THE MOST CELEBRATED example of loyalty and warrior ethics in Japanese history. It dramatically illustrates the finest qualities of the samurai code of honor.

The story begins in 1701 during the Tokugawa Tsunayoshi shogunate (1646–1709). When Japanese emperor Higashiyama sent envoys on a visit to the shogun's court in Edo (present-day Tokyo), the shogunate instructed two feudal lords—Kamei Sama and Asano Naganori (the lord of Ako)—to look after the envoys during their visit.

Kira Yoshinaka, a powerful official in the shogunate hierarchy, was named master of ceremonial duties for the visit. Kira, who is often portrayed as mean-spirited, rude, villainous, and corrupt, expected both lords to give him important gifts or bribes in return for instruction in the intricacies of proper court etiquette. He was greatly offended when he received what he felt were inadequate gifts, so he became uncooperative and treated both lords terribly.

At first Asano took everything stoically, but Kamei Sama was infuriated and ready to kill Kira. Kamei's quick-thinking advisers secretly offered Kira a large bribe, after which Kira began to treat Kamei more politely. However, Kira continued to treat Asano like a country bumpkin, and soon Asano became so humiliated that, in a rage, he drew his sword and superficially wounded his tormentor on the forehead.

To have drawn his sword within the shogun's castle grounds and so violated the rules of decorum was a serious offense, so the authorities instructed Asano to commit seppuku the same day. At the age of only 34, Asano did as ordered. His fief was confiscated, his family was ruined, and his feudal retainers lost their samurai status, becoming *Ronin* (wave men), which means masterless samurai.

Asano's chief retainer, Oishi Kuranosuke, was angered at the shogun's failure to have Kira share responsibility for the incident and felt that the punishment for Asano was too harsh. He appealed to the other Ako Ronin, reputedly numbering 320, to take vengeance

upon the lord who had caused their master's downfall. A total of 46 responded and joined in the secret pact, even though they knew that carrying out such an act would be akin to signing their own death warrant.

Realizing that Kira and the authorities would be watching for them to take revenge, the 47 Ronin decided to quell suspicions by disbanding and taking up different occupations; they would regroup much later to carry out their plot. Some Ronin became menial work-men and merchants to gain access to and become familiar with Kira's fortified mansion. One Ronin even married the daughter of the builder of Kira's mansion, so that he could obtain construction plans for the house.

Oishi put on the greatest charade to lull Kira into a false sense of security. To prove that there was nothing to fear from him, Oishi deliberately soiled his own reputation. He

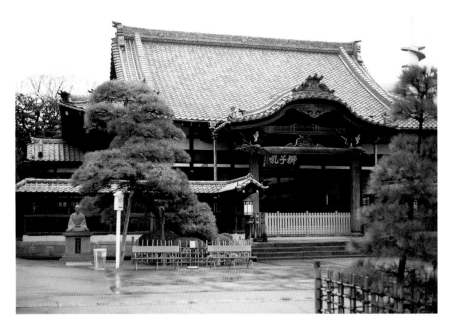

divorced his wife of twenty years and took up a life of drunken debauchery and degradation in the pleasure quarters of Kyoto, squander-ing his money and disgusting many of his intimate friends and colleagues. One day a samurai from Satsuma recognized

Sengakuji Temple, Tokyo.

Oishi, who was in a drunken stupor on the street, and mocked him, kicked him in the face, and spat upon him to show his contempt for Oishi's behavior.

On the snowy evening of December 14, 1702, in accordance with Oishi's plan, the Ronin reassembled at a secret meeting place at Honjo, outside Edo, ready to assault Kira's heavily guarded mansion. They sent messages to nearby houses to inform them of their intentions, and then stormed the residence of their enemy with a war drum, whistle, ladders, battering mallets, and weaponry.

Oishi had some men scale the wall and tie up the people in the porter's lodge; he then posted archers on the walls to prevent any messengers from getting out to seek help. According to a carefully laid-out plan, the Ronin then split into two groups, simultaneously attacking the front and back gates at the sound of a drumbeat. Kira and his retainers were caught completely off guard and had to battle barefoot in the snow. Many tried to flee. (Legend has it that the Ronin killed about 40 of Kira's men, but to save face, samurai of the Uesugi clan later dragged away some 23 corpses to lower the official tally.)

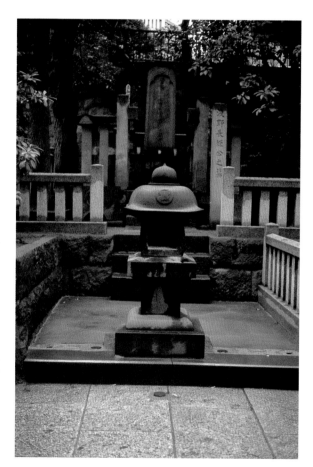

Grave of Lord Asano.

Dressed only in his underwear, Kira hid in a charcoal shed. After a tense hour of searching, the Ronin discovered him, recognizing him by the scar their master had left on his head. Oishi, out of consideration for Kira's high samurai rank, dropped to his knees and invited Kira to do the honorable thing: commit seppuku with the same dirk that their master, Asano, had used for his own suicide. Sensing that this was not going to happen, Oishi executed and beheaded Kira, who was shaking in fright.

The Ronin then gathered in the courtyard, and a roll call confirmed that 46 were present; only 4 were wounded, and they could still walk. As day was breaking, the Ronin, carrying Kira's head, headed for their lord's grave at the Sengakuji temple. They caused quite a stir along the way; as their courageous story rapidly spread, many well-wishers en route offered them refreshments. When the Ronin arrived at their master's tomb, Oishi washed the bloody head of Kira and placed it in front of the grave. Then, having completed their vendetta, the Ronin surrendered to the city magistrate. Forty-six of the Ronin were divided into four groups and guarded in the homes of four

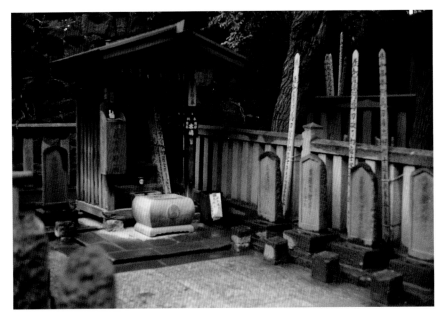

Grave of Oishi.

14

different daimyo —Hosokawa, Matsudaira, Mari, and Midzuno—until their fate could be decided.

Conflicting stories relate to the fate of the forty-seventh Ronin. According to one story, a Ronin died before the assault on Kira's mansion. Another says that one of the youngest Ronin was sent to the group's homeland of Ako to inform everyone that the vendetta had been accomplished. According to this story, when this young Ronin eventually returned to Tokyo he was pardoned by the shogun—perhaps because of his youth—lived until he was 78, and was buried with his colleagues. Yet another version of the forty-seventh Ronin says that Oishi dismissed one of his followers after the attack because he was a foot soldier and not of the samurai class, thus leaving a witness to the Ronin's loyalty; this warrior, Terasaka Kichiemon, lived to the age of 83.

The Ronin's self-sacrificing loyalty to their master and their return to the medieval idealism of "death before dishonor" made them instant national heroes. Their faultless adherence to the old warrior's code of bushido, which many

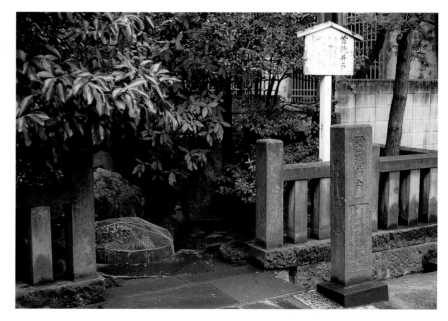

Well used for washing the severed head of Kira.

felt had been eroding for a century, captured the public's consciousness. Expressions of admiration and cries for clemency rang throughout the land. It was the most exciting and heroic event to happen in Japan in a long time.

As a result, controversy grew as to what punishment—if any—should be meted out to the Ronin. Although the shogun was inclined to spare them, his counselors and Confucian scholars were not. They agreed that the action of the Ronin was inspired by the highest motives and was the behavior of true samurai. Nevertheless, the Ronin had flouted the law, so they must atone for their crime.

After almost two months of debate, the government reached a decision on February 4, 1703: the Ronin would be allowed the honorable death of seppuku, so that they could die as martyrs instead of being executed as criminals. The four daimyo guarding the 46 Ronin stalled the order until dusk, hoping that it had been a "save face" sentence to be followed by a pardon, but it never came. The penalty was what the Ronin had expected; each committed suicide by the painful method. The Japanese population was furi-

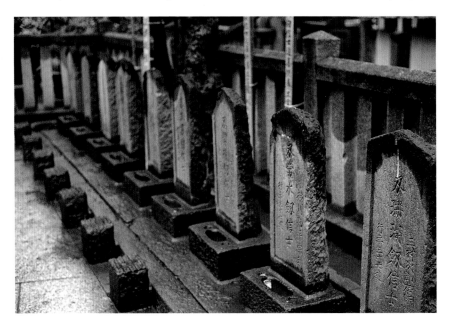

Wide shot of the graves of the 47 Ronin.

ous with the government for not granting amnesty, and some people scribbled satirical verse and angry epithets vilifying the government and officials for their failure to pardon the Ronin.

Oishi was 45 when he committed seppuku. Most of the other Ronin were in their 20s and 30s, but the oldest, Horibe Yahyoe, was 77, and the youngest—Oishi's eldest son, Chikara—was only 16. As the Ronin had requested, all their tombs were placed close to that of their master, the simple graves standing side by side in Tokyo's quiet little Sengakuji Temple.

Among the first people to come and pay respects was the Satsuma samurai who had spat on the drunken Oishi. At Oishi's grave, the samurai apologized for his behavior, begged for forgiveness, then committed seppuku. He is buried next to the graves of the courageous Ronin.

Although the primary purpose of the Ronin's mission was to avenge and to show loyalty to Lord Asano, another motive was to reestablish Asano's lordship in Ako. Because of all the publicity that the Ronin vendetta

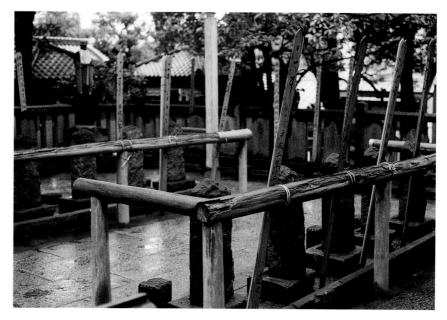

Wide shot of the graves of the 47 Ronin.

garnered, the Tokugawa shogunate decided to allow Asano's eldest son to reclaim his father's territory, even though it was reduced to a tenth of its original size.

For their admirable display of faithfulness to the precepts of bushido, the Ronin became instant heroes (*gishi*—righteous warriors) to the Japanese people. To this day, people still flock to their graves to burn incense in their honor. The small Hyogo seaside town of Ako, from where the Ronin were employed, celebrates each December 14 with a local holiday and Gishisai festival to commemorate the 47 Ronin. A similar festival is held the same day at Sengakuji Temple, which has preserved the Ronin's clothes and weapons as well as the drum and whistle used for signals during the attack.

The story became a pop culture favorite known to adults and children alike as the ultimate example of self-sacrifice. Countless *Kabuki* dramas, *Bunraku* puppet plays, films, movies, television adaptations, and woodblock prints have been produced to commemorate the event. In fact, within weeks of their deaths, the Ronin were celebrated in a Soga Brothers play created for the Edo stage. Later, the puppet play

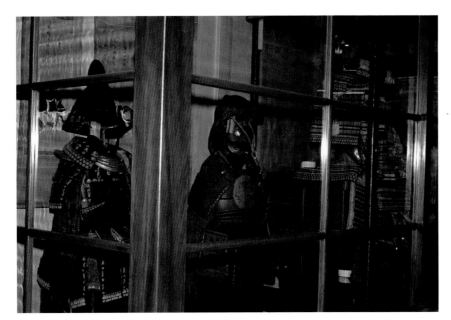

Actual armor worn by the 47 Ronin, on display in the temple.

and subsequent Kabuki plays with the title *Chushingura* (The Treasury of the Loyal Retainers), based on the Ronin story, became a major hit and often moved audiences to tears.

Many well-known *ukiyo-e* artists such as Utamaro, Hokusai, Kunisada, Hiroshige, and Kuniyoshi designed one or more series of woodblock prints based on the play. Both Hiroshige and Kuniyoshi produced several series with the theme, and Kuniyoshi even made a complete set of individual portraits based on the series. A number of later artists, including Yoshitoshi, Yoshitora, and Kuniteru II, also depicted the story. In woodblock prints the Ronin were usually depicted wearing distinctive black-and-white dogtooth jackets, a design not actually worn by the Ronin but used in the theatrical productions. This black-and-white iconographic device represents the unquestionable progression of night and day, which symbolizes unfailing loyalty. Each Ronin actually did wear a small wooden tag bearing his name—for identification of the corpse if the mission failed.

Actual armguards and protective panels worn by the 47 Ronin.

FURTHER READING

Allyn, John. *The Forty-Seven Ronin Story.* Boston: Tuttle Publishing, 1970.

Dickens, Frederick V. *Chushingura, or the Loyal League.* New York: G. P. Putnam's Sons, 1876. Reprint, London: Allen & Co., 1880.

Keene, Donald (translator). *Chushingura: A Puppet Play.* New York: Columbia University Press, 1971.

Mitford, A. B. *Tales of Old Japan.* London: Macmillan and Co., 1871. Reprint, Princeton, NJ: Princeton University Press, 1989.

Stewart, Basil. *Subjects Portrayed in Japanese Colour-Prints.* London: K. Paul, Trench, Trubner & Co., Ltd., 1922. Reprint, New York: Garland Publishing, 1979.

Tatsuo, Takei and David Pepper. Exhibition catalog, *The Faithful Samurai.* Dearborn, MI: Alfred Berkowitz Gallery, October 6–December 12, 2003.

Till, Barry. *Samurai: The Warrior Class of Japan.* Victoria, BC: Art Gallery of Greater Victoria, 2003.

Weinberg, David R. *Kuniyoshi, The Faithful Samurai.* Amsterdam: Hotei Publishing, 2000.

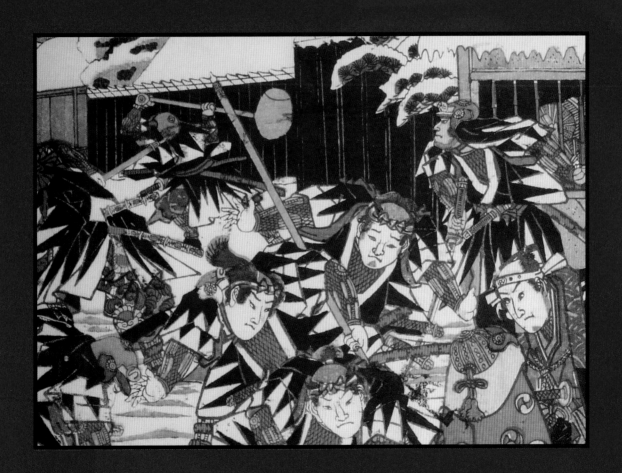

*T*HESE ILLUSTRATED WOODBLOCK PRINTS BY VARIOUS ARTISTS
are of scenes from the puppet and Kabuki play *Chushingura* (The Treasury of the Loyal
Retainers). The prints, which belong to the Art Gallery of Greater Victoria, British
Columbia, Canada, include two different series of the play—one full set of sixteen prints
published by Senichi and one partial set published by Fuji-hiko— by Ando Hiroshige
(1797–1858); one full series of twelve prints by Ichimosai Yoshitora (active 1850–1880);
portions of other series by Yamada Kuniteru (1829–1874) and Utagawa Kuniyoshi
(1798–1861); and two prints by Utagawa Kunisada (1786–1865), one depicting a Kabuki
actor portraying a Ronin.

Because the censorship laws of the Tokugawa or Edo period (1615–1868) forbade the
use of real names in historical depictions, the character names, locations, and time period of
the real 47 Ronin were carefully changed in the theatrical plays and woodblock prints so as
not to offend the Tokugawa shogunate. The *Chushingura* play had a labyrinth of twisting
subplots that often bore little relation to the actual historical incident.

With the story altered, the names changed, and a number of secondary characters added,
the prints illustrating the various chapters of the play often go off on tangents to the actual
story. The disguised play was set in the fourteenth century, and the scene of the vendetta
was changed from Edo to Kamakura. The names of the principal characters Asano, Kira,
and Oishi became Enya, Moronao, and Oboshi, respectively.

To identify the activities in the print scenes and their relation to the story, it is necessary
to briefly summarize some scenes from the long and complex play *Chushingura*, while
keeping the above historical summary in mind.

ACT I. The wife of Lord Enya (Asano) is asked to come to the Hachiman Shrine in
Kamakura to identify which of 47 helmets belongs to the slain general Yoshisada (she had

been an attendant in his household). While inspecting the helmets, Moronao (Kira) makes inappropriate advances toward Lady Enya. She politely rejects Moronao, but by doing so causes him to dislike her husband.

ACT II. Many subplots are introduced, including a romance between Rikiya, the son of Oboshi (Oishi), and Konami, the daughter of Honzo, who is the chief counselor to Wakasa (Kamei Sama). Wakasa is enraged at Moronao's insults and plans to kill him. Honzo decides to secretly bribe Moronao so that he will treat Wakasa more politely.

ACT III. Honzo offers bribes to Moronao's retainer, Bannai. Moronao starts treating Wakasa differently but becomes more insulting to Enya, who finally attacks his insufferable tormentor. Honzo restrains Enya, but Enya must now commit seppuku for his actions. Kampei, one of Enya's retainers, who should have been protecting Enya, was instead flirting with a maid, Okaru. Kampei realizes his grave error and decides to commit suicide, but Okaru persuades him to run off to her parents' house.

ACT IV. Enya commits seppuku, with his faithful retainer Oboshi by his side. Lady Enya has been given cherry blossoms to distract her from the deadly deed.

ACT V. Kampei is living with Okaru and her parents. The Ronin are uncertain of Kampei's loyalty to their cause. Okaru's parents secretly sell her to a brothel to help redeem Kampei's honor. (Her parents are gathering the money for Kampei so that he can contribute to the revenge plot against Moronao.) Okaru's father, Yoichibei, is robbed and stabbed to death while returning home with the money. Kampei, who is hunting in the evening with a gun at the time, then accidentally kills the murderer and finds the purse of money.

ACT VI. The brothel owner shows up to collect Okaru at her home. When Kampei hears the story about the purse of money, he thinks that he has killed his father-in-law, Yoichibei. Some hunters show up with Yoichibei's corpse, so Kampei decides to commit suicide. As he is dying, everyone realizes that the body was stabbed and not shot; hence Kampei did not kill him but killed the murderer. Two Ronin who are wearing basket hats to hide their identity come by and are moved by Kampei's story. They include him in their pact for his large contribution of money. Before he dies, he signs in blood a scroll that includes his name in the vendetta.

ACT VII. Surrounded by teahouse girls, Oboshi dines with Moronao's spy, Kudayu, at the Ichiriki brothel, to fool him with his bad behavior.

ACT VIII. Preparations are underway for the marriage of Rikiya and Konami and for Konami's bridal journey.

ACT IX. Oboshi and Honzo meet to resolve Honzo's duplicity in Lord Enya's death. In one scene, Oboshi and Rikiya bid a tearful farewell to Konami in the foreground, as Honzo commits suicide in the background.

ACT X. Nine Ronin, dressed in black, carry a concealed Oboshi in a large basket. They plan to test the loyalty of Gihei, a merchant who supplies their weapons. Gihei had even divorced his wife, Osono, to ensure her ignorance of the plot against Moronao. He proves to have been extremely loyal. In another scene, a Ronin cuts off Osono's hair, to make her look like a nun and to prevent her from having to remarry at her father's wishes, so that eventually she and her husband can be reunited.

ACT XI. The last and most spectacular act features the famous night attack on Moronao's mansion and six episodes highlighting subsequent events.

FIRST EPISODE. In the background, the Ronin cross a bridge at night on their way to attack Moronao's residence. In the foreground, two Ronin have crossed the river in a boat. In the event that someone tries to attack them on the way back, the boat will be used to escape with their enemy's head.

SECOND EPISODE. The Ronin are attempting to break into Moronao's residence by forcing out the shutters with bent bamboo. One Ronin is armed with a large ax, and another carries a huge mallet to break down doors.

THIRD EPISODE. The Ronin have dragged Moronao from his hiding place and invited him to commit seppuku with the same dirk that their master used to kill himself. Moronao refuses and is then beheaded.

FOURTH EPISODE. Carrying the severed head of their enemy, the Ronin, who are nearing their master's grave, are stopped by foot soldiers of the Prince of Sendai. He has heard about their valiant deed and wishes to invite them in for rest and refreshments, an offer that they gratefully accept.

FIFTH EPISODE. On their way to their master's grave, a feudatory stops the Ronin and does not allow them to cross Ryogoku Bridge; they must use another bridge.

SIXTH EPISODE. The Ronin enter the Sengakuji Temple to present the head of their enemy at their master's grave.

Ando Hiroshige

1797–1858

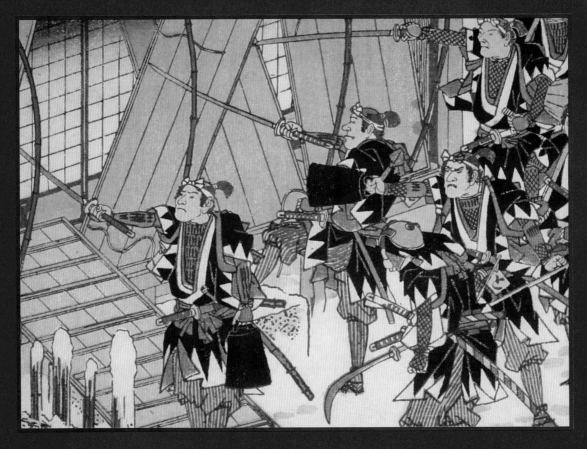

The Loyal League of the Forty-Seven Ronin, woodblock prints, Senichi Series (16 prints)
Hildegarde Wylie Memorial Fund, Art Gallery of Greater Victoria, 62.216

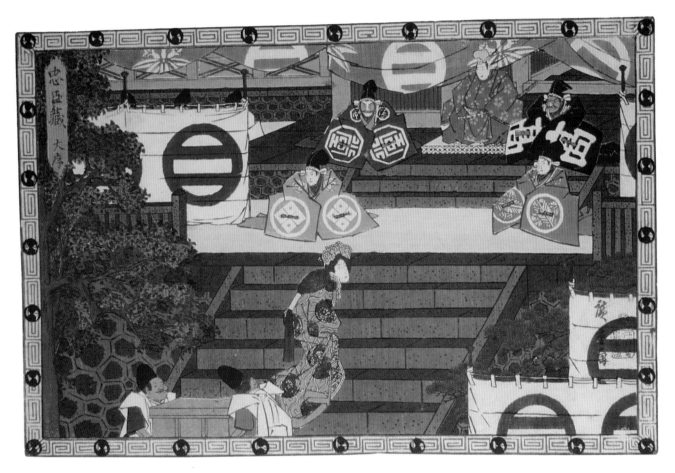

Act I. Lady Enya with Tadayoshi (deputy for the shogun), Moronao, and Wakasa at Hachiman Shrine.

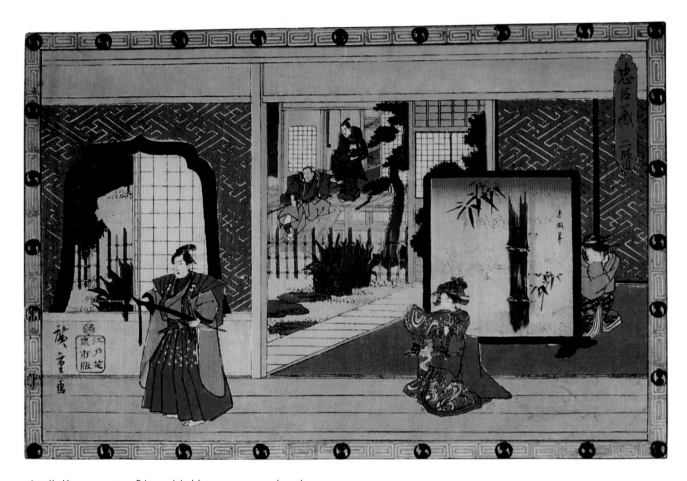

Act II. Konami receives Rikiya while Honzo cuts a pine branch.

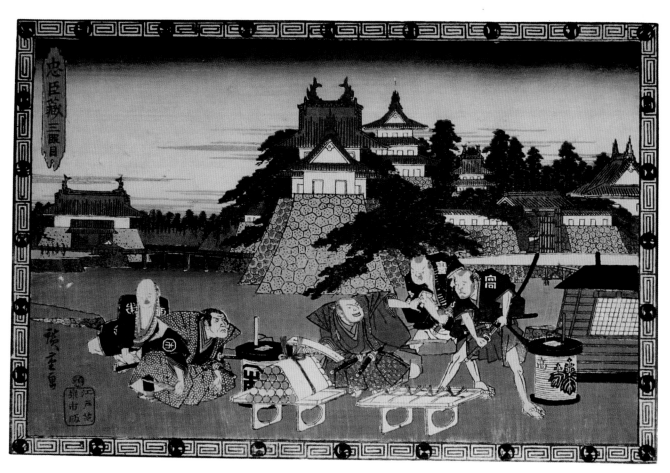

Act III. Honzo presents bribes to Bannai to appease Moronao.

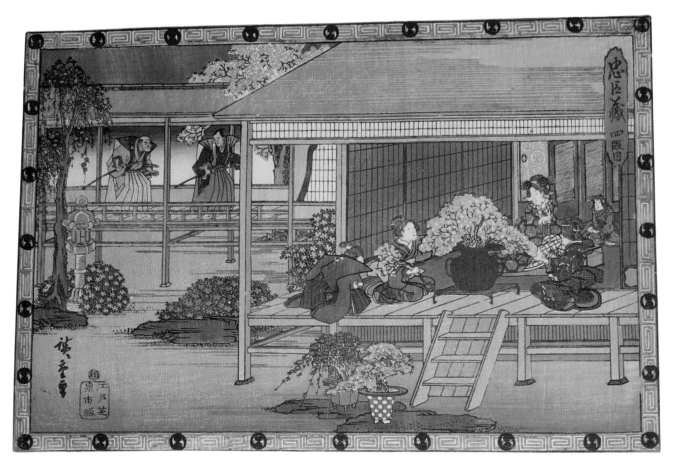

Act IV. Lady Enya beside cherry blossoms, trying to distract herself from the pending suicide of Lord Enya.

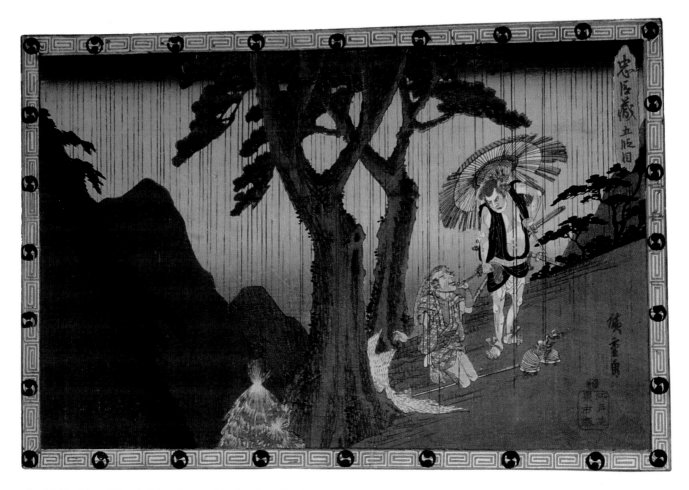

Act V. Yoichibei, Okaru's father, being robbed and murdered.

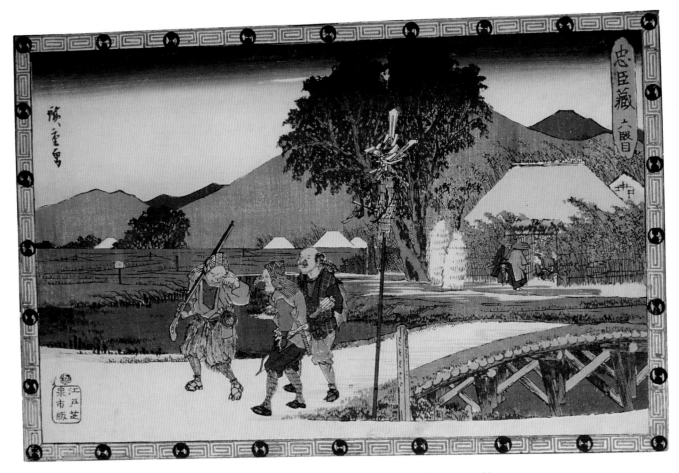

Act VI. Three hunters bringing Yoichibei's corpse; background: two Ronin wearing basket hats visiting Kampei.

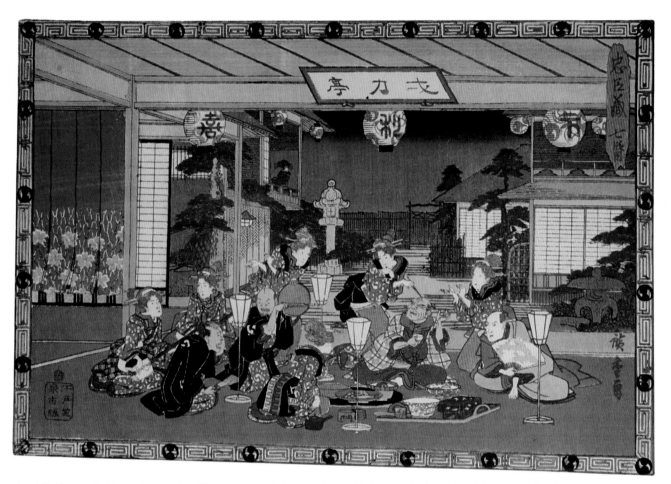

Act VII. Surrounded by teahouse girls, Oboshi dines with Moronao's spy, Kudayu, at the Ichiriki brothel, trying to fool him with his bad behavior.

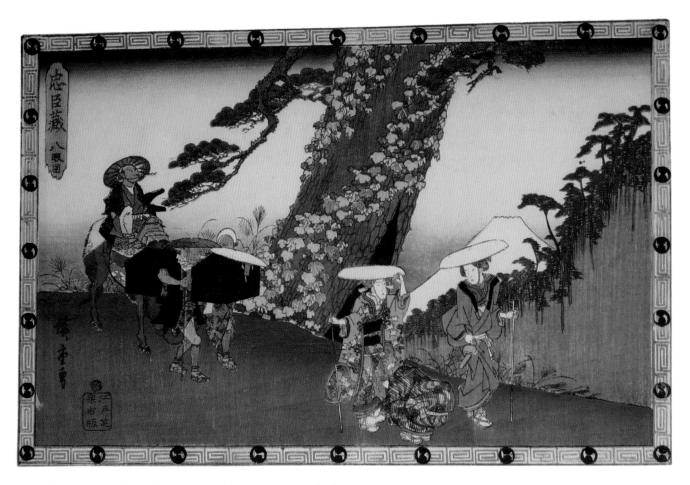

Act VIII. Konami and her mother on the bridal journey, searching for Rikiya.

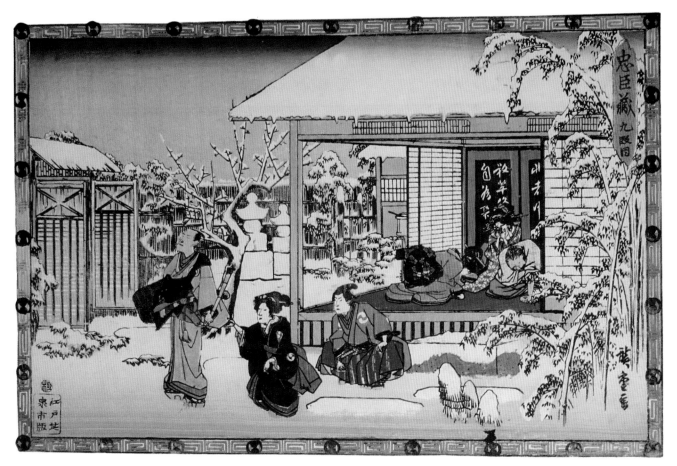

Act IX. Honzo, about to commit suicide because of his complicity in Lord Enya's death. Foreground: Oboshi, about to leave for vendetta.

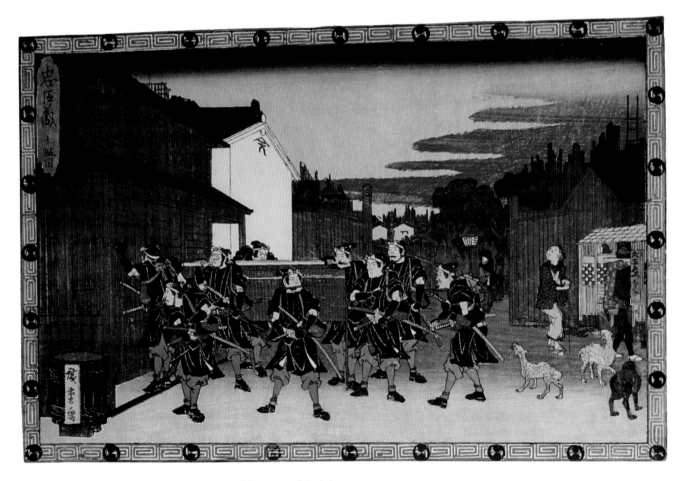

Act X. Ronin carrying a large basket that hides Oboshi into Gihei's house.

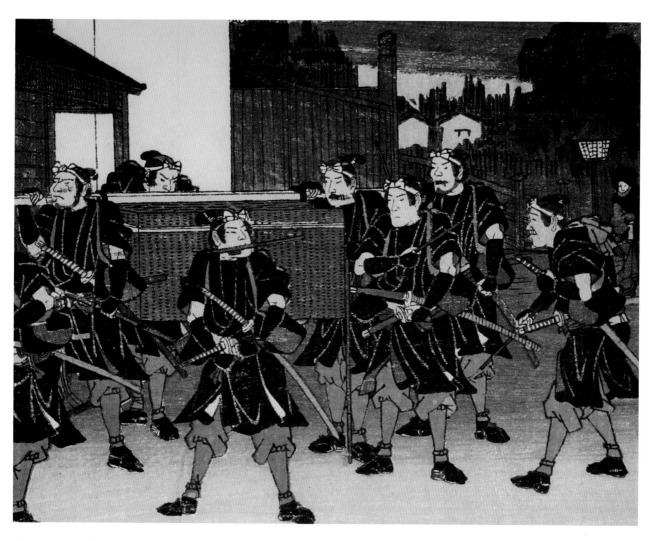

Detail from woodblock print on facing page.

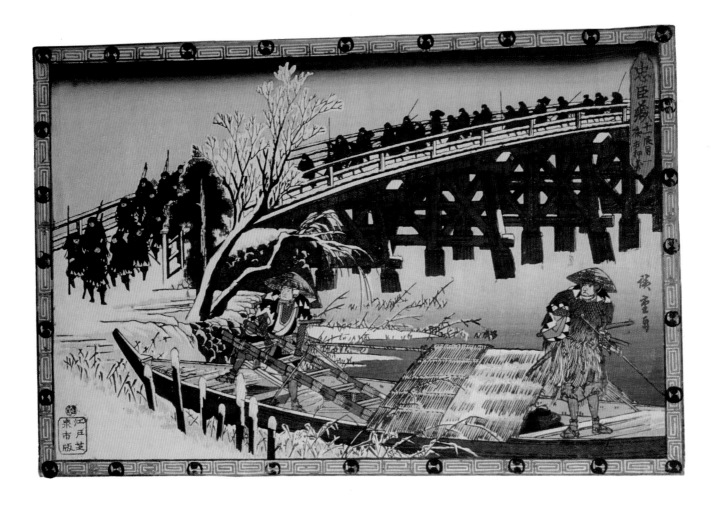

Act XI. First Episode. Ronin crossing the bridge on the way to Moronao's mansion. The boat in foreground will be used to transport the severed head if there is a problem.

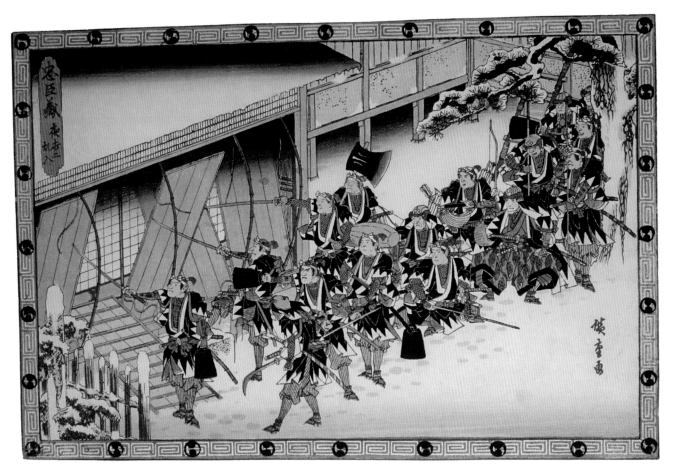

Act XI. Second Episode. Ronin breaking into Moronao's mansion.

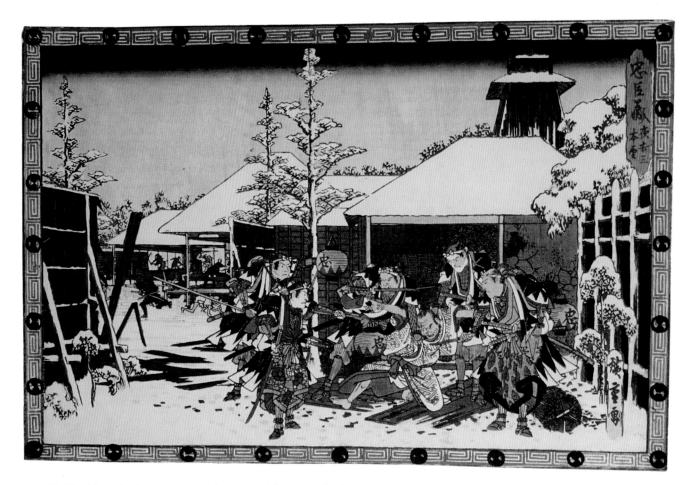

Act XI. Third Episode. Ronin capturing Moronao and then beheading him.

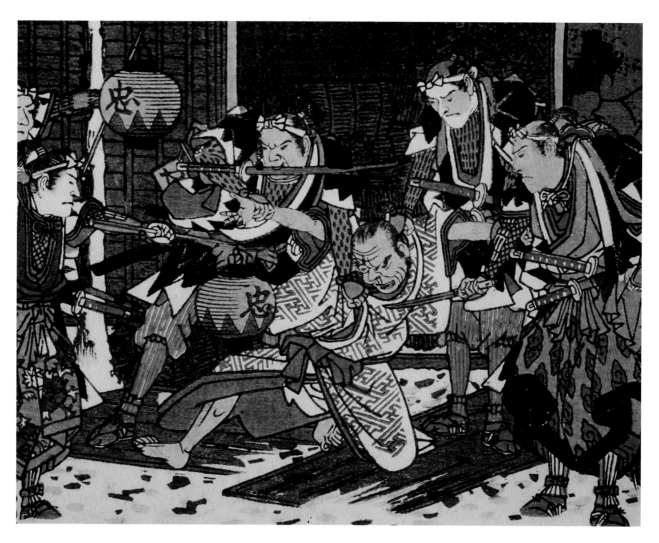

Detail from woodblock print on facing page.

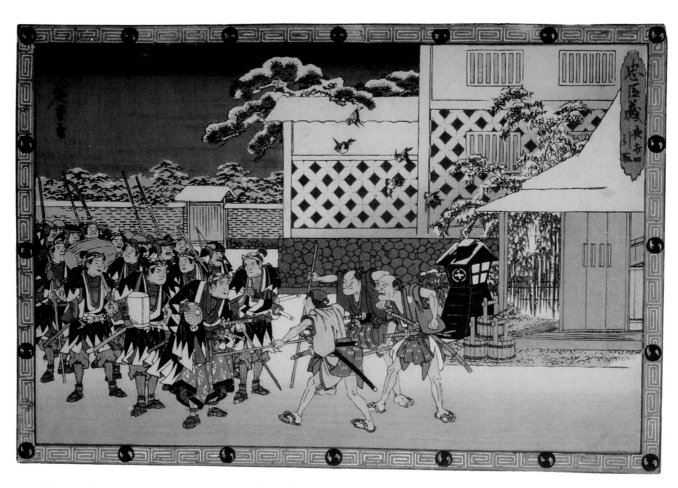

Act XI. Fourth Episode. Ronin being stopped and offered refreshments.

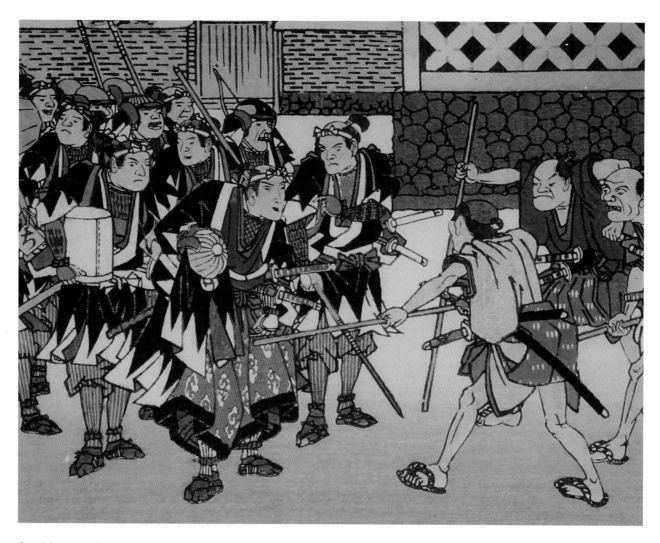

Detail from woodblock print on facing page.

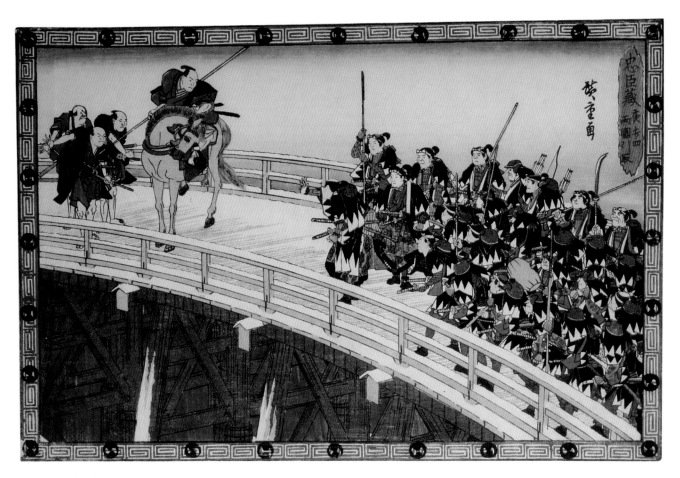

Act XI. Fifth Episode. Ronin being stopped and prevented from crossing Ryogoku Bridge.

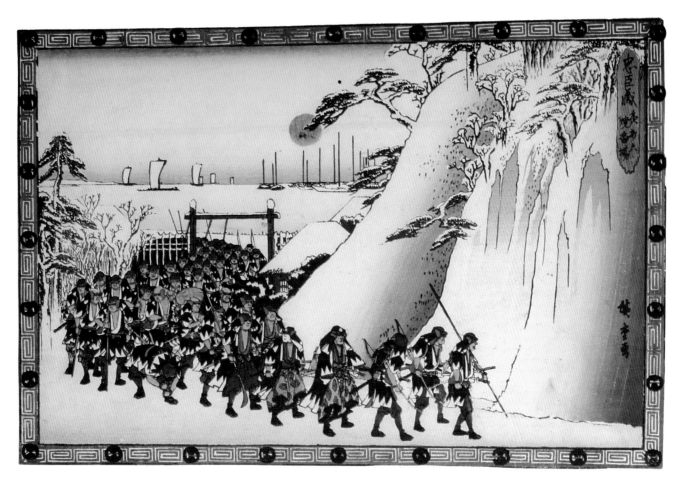

Act XI. Sixth Episode. Ronin enter Sengakuji Temple to present the severed head at their master's grave.

Ando Hiroshige

1797–1858

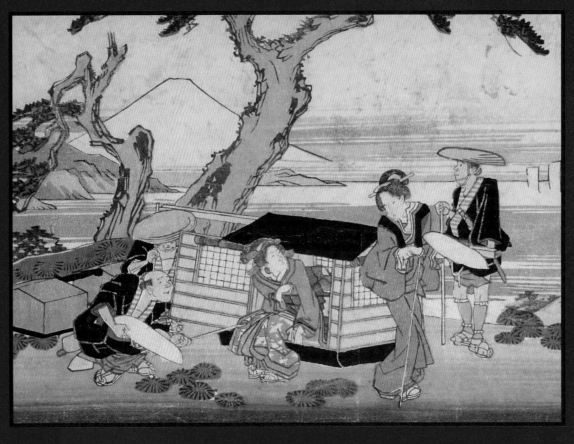

THE LOYAL LEAGUE OF THE FORTY-SEVEN RONIN, WOODBLOCK PRINTS, FUJI-HIKO SERIES (8 PRINTS)

GIFT OF MRS. H. MORTIMER-LAMB IN MEMORY OF H. MORTIMER-LAMB

ART GALLERY OF GREATER VICTORIA, 63.144

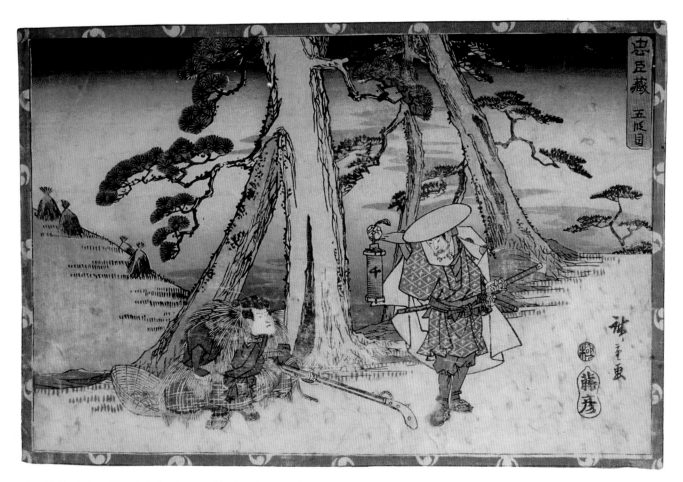

Act V. Yoichibei, Okaru's father, being robbed and murdered.

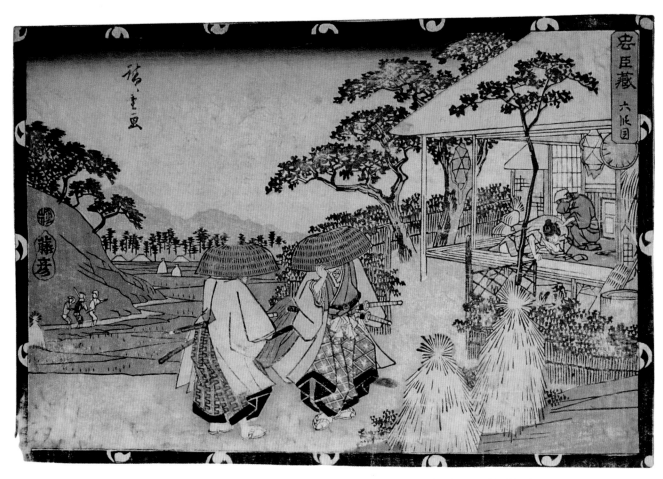

Act VI. Two Ronin wearing basket hats visiting Kampei; background: three hunters leaving after bringing Yoichibei's corpse.

48

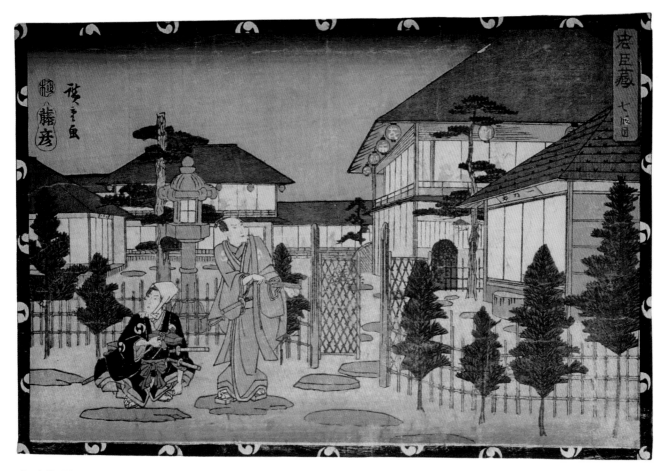

Act VII. Rikiya brings a letter concerning Moronao to his father, Oboshi, at the Ichiriki brothel.

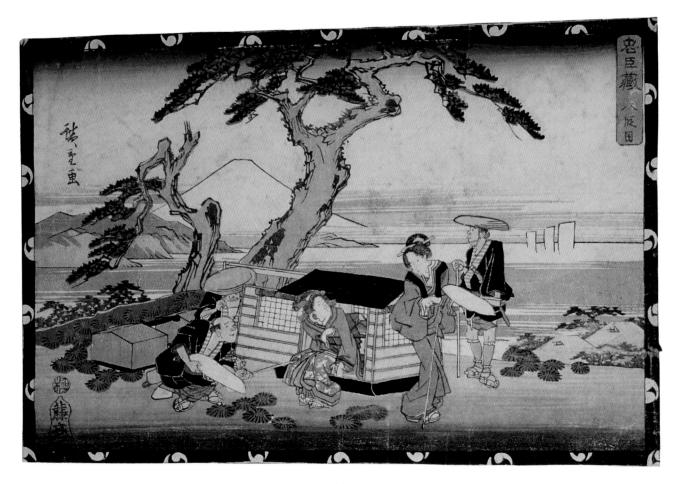

Act VIII. Konami and her mother on the bridal journey, searching for Rikiya.

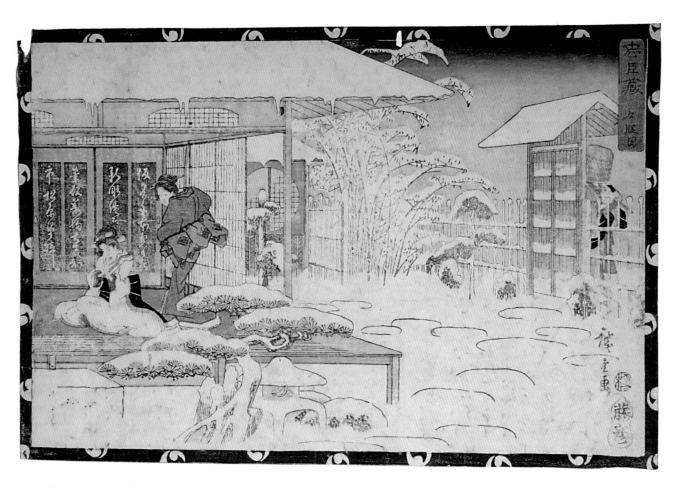

Act IX. Honzo's wife, Tonase, about to take the life of her daughter, Konami; Honzo, wearing a basket hat and playing a flute, appears at the gate.

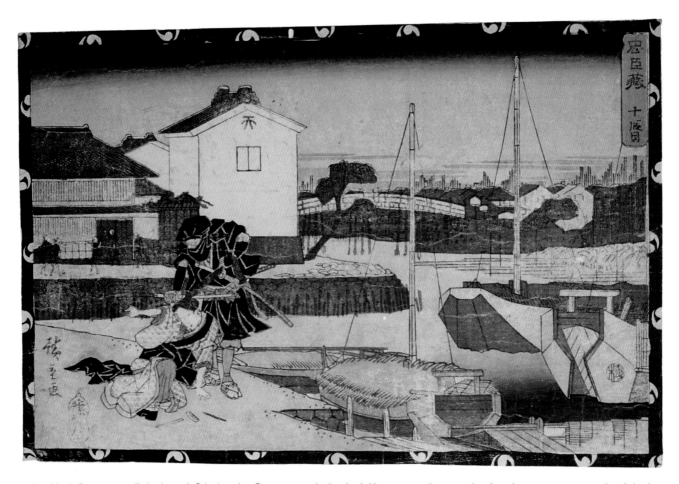

Act X. A Ronin cuts off the hair of Gihei's wife, Osono, to make her look like a nun and prevent her from having to remarry at her father's wishes, so eventually she and her husband can be reunited.

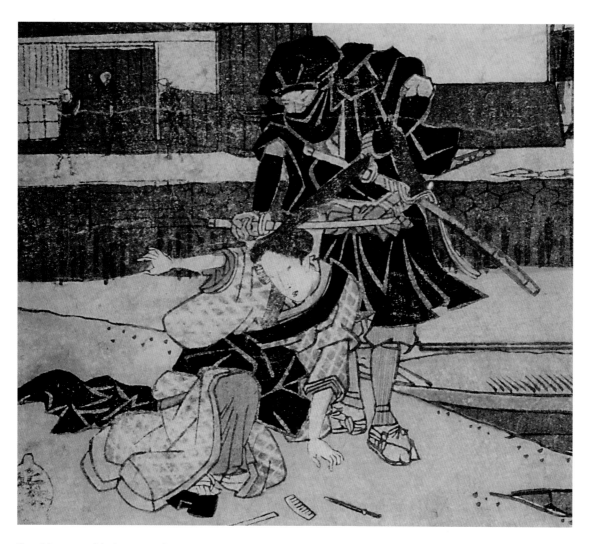

Detail from woodblock print on facing page.

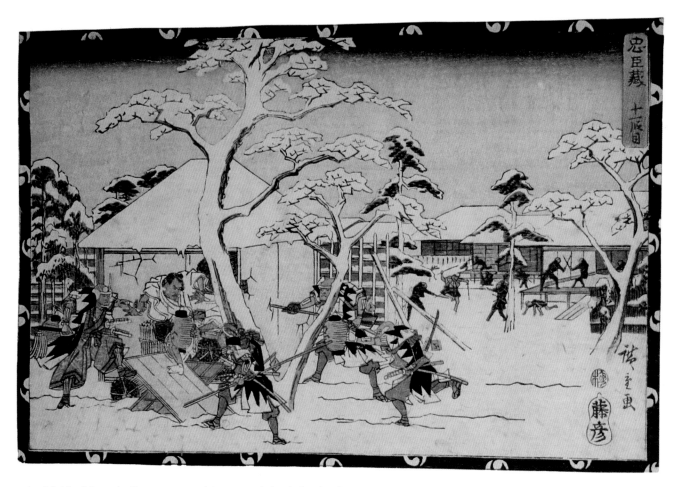

Act XI. Third Episode. Ronin capturing Moronao and then beheading him.

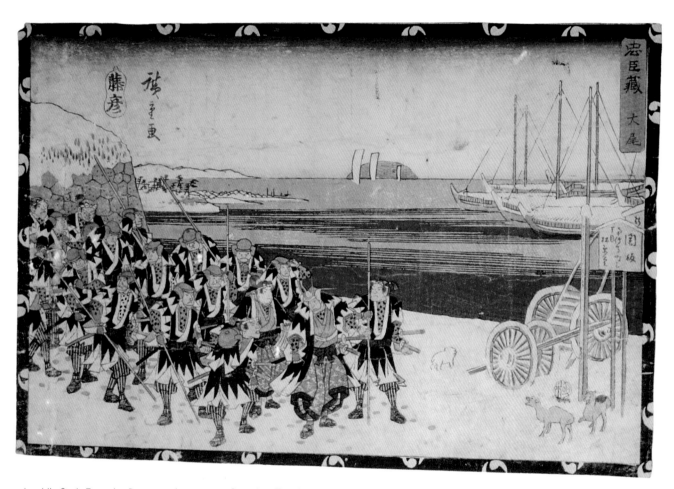

Act XI. Sixth Episode. Ronin on their way to Sengakuji Temple, to present the severed head at their master's grave.

Ichimosai Yoshitora

ACTIVE 1850–1880

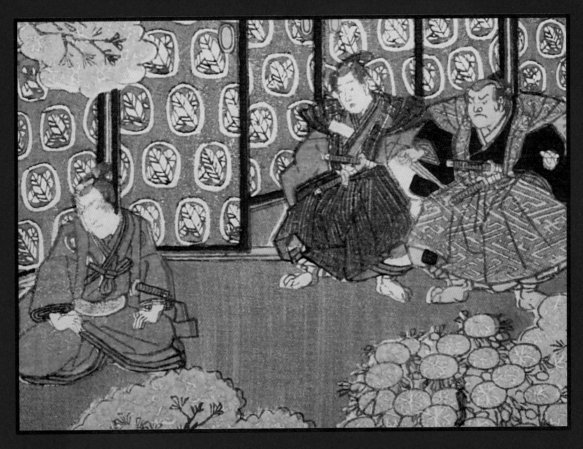

THE LOYAL LEAGUE OF THE FORTY-SEVEN RONIN, WOODBLOCK PRINTS (12 PRINTS)
GIFT OF MR. THEODORE LANDE, ART GALLERY OF GREATER VICTORIA, 84.54.7

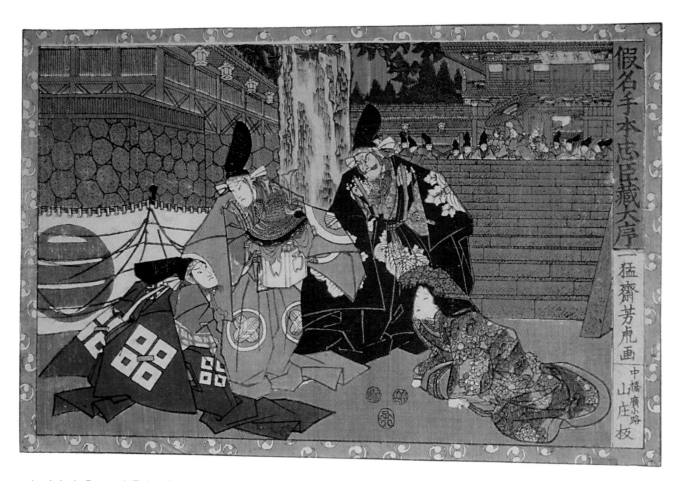

Act I. Lady Enya with Tadayoshi (deputy for the shogun, Moronao) and Wakasa at Hachiman Shrine.

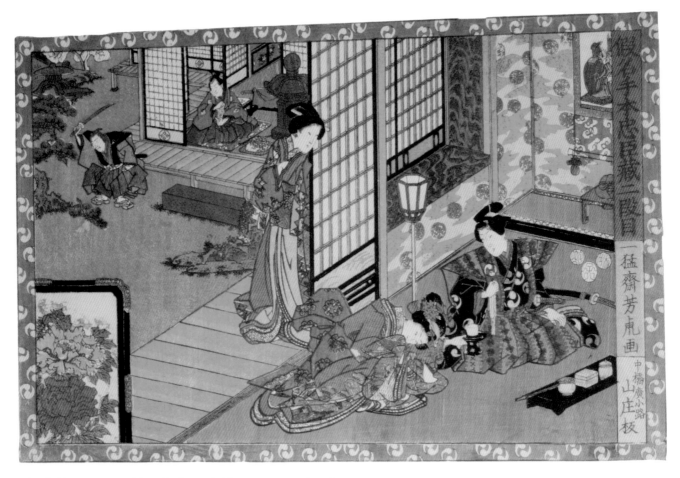

Act II. Konami receives Rikiya; background: Honzo cuts a pine branch.

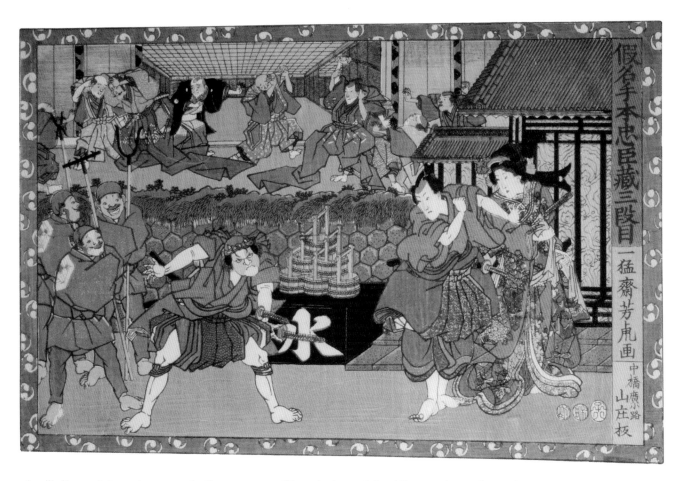

Act III. Kampei fights with a group of ruffians to protect Okaru; background: Lord Enya attacking and wounding Moronao.

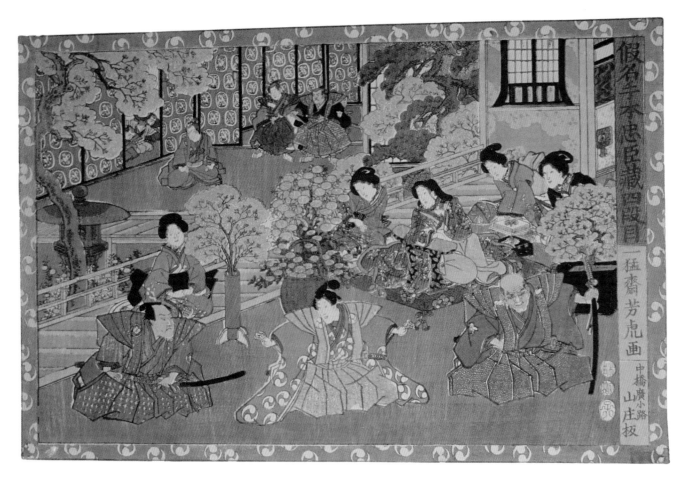

Act IV. Lady Enya beside cherry blossoms, trying to distract herself from the pending suicide of Lord Enya, who is in the background, about to commit suicide.

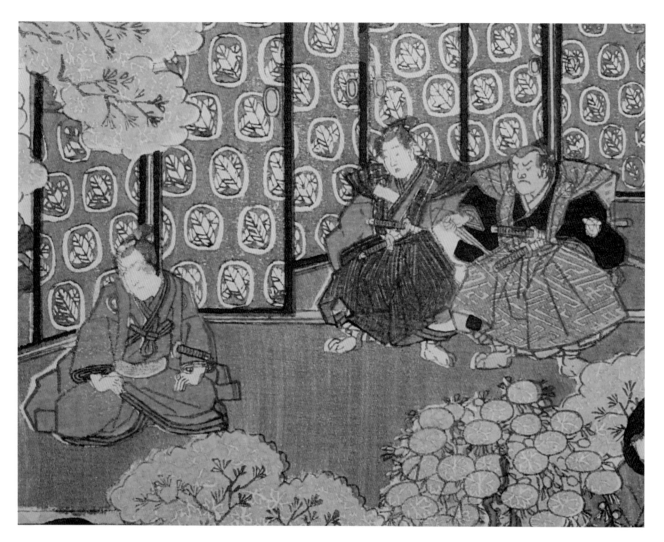

Detail from woodblock print on facing page.

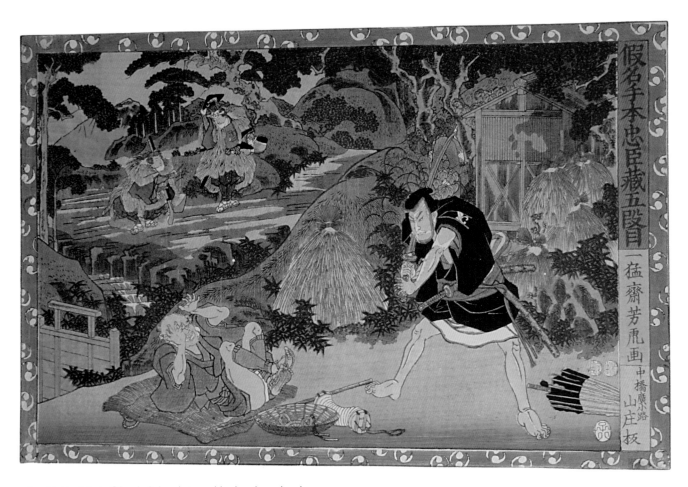

Act V. Yoichibei, Okaru's father, being robbed and murdered.

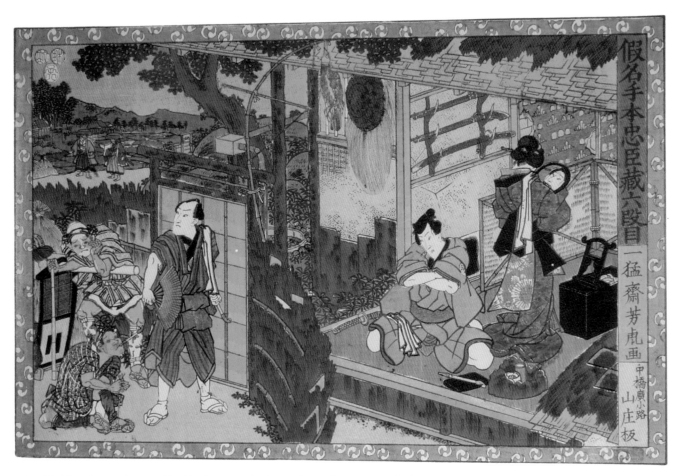

Act VI. Three hunters bringing Yoichibei's corpse; background: two Ronin wearing basket hats visiting Kampei.

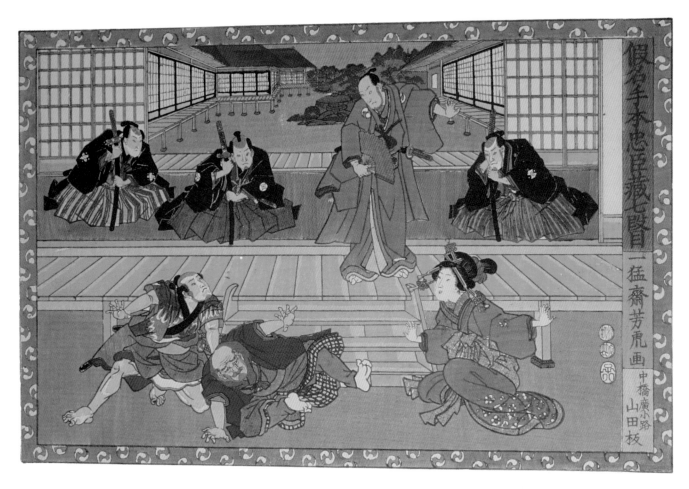

Act VII. Oboshi dines with Moronao's spy, Kudayu, at the Ichiriki brothel, to fool him with his bad behavior.

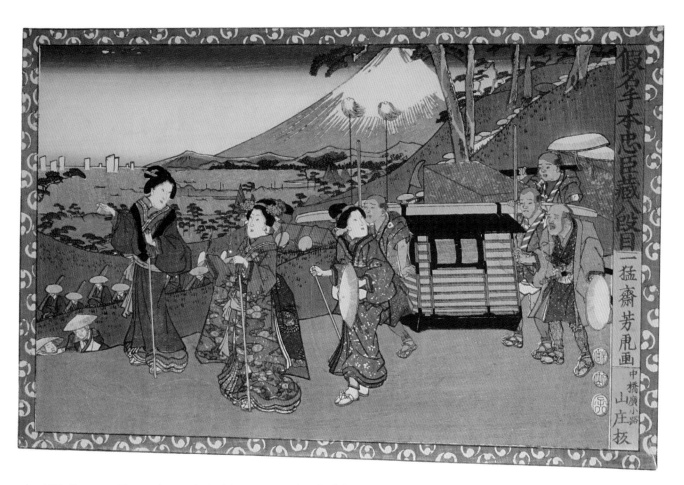

Act VIII. Konami and her mother on the bridal journey, searching for Rikiya.

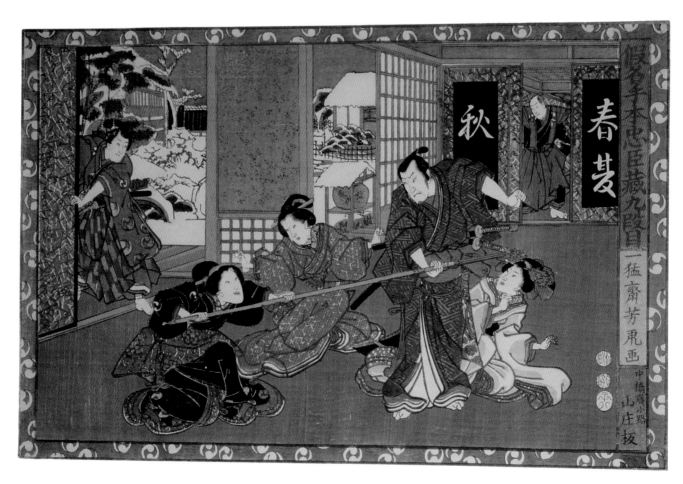

Act IX. Honzo about to commit suicide for his complicity in Lord Enya's death; at the side: Oboshi about to leave for vendetta.

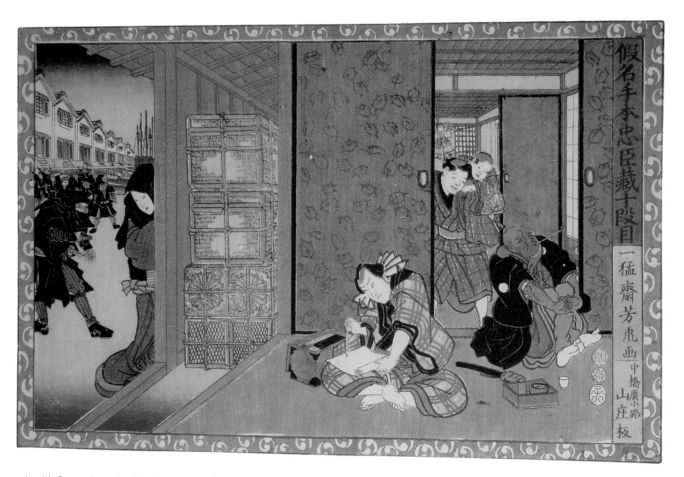

Act X. Ronin dressed in black coming to Gihei's house to test his loyalty, with Gihei's divorced wife standing outside the doorway.

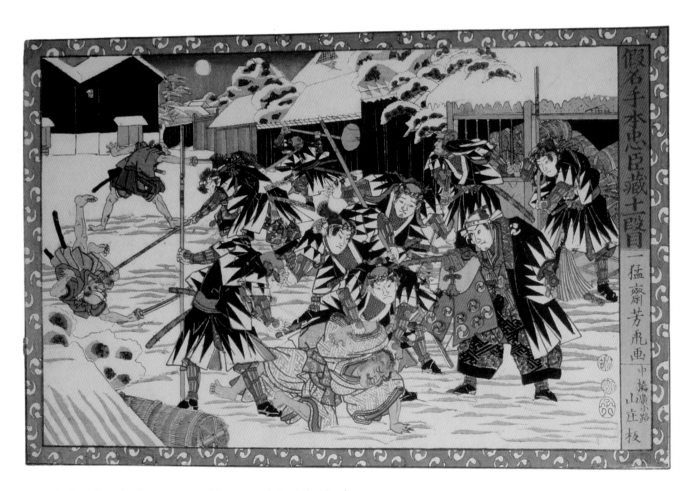

Act XI. Third Episode. Ronin capturing Moronao and then beheading him.

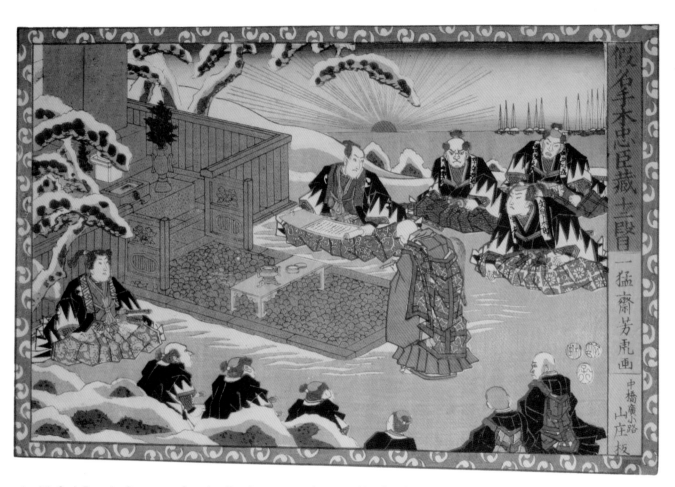

Act XI. Sixth Episode. Ronin enter Sengakuji Temple to present the severed head at their master's grave.

Yamada Kuniteru II

1829–1874

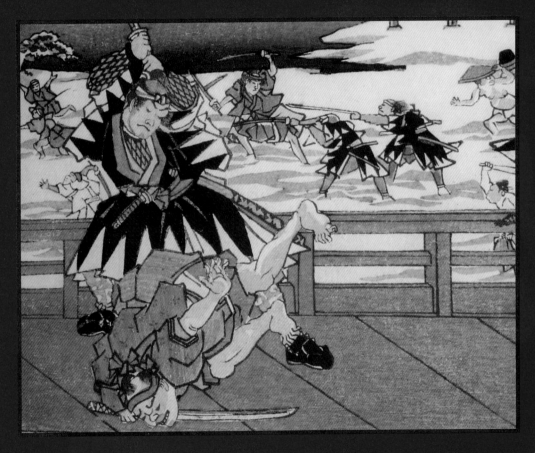

SERIES: THE LEAGUE OF THE FAITHFUL RETAINERS, WOODBLOCK PRINTS
GIFT OF MARGARET G. NORMAN, ART GALLERY OF GREATER VICTORIA, 97.20.5-.7

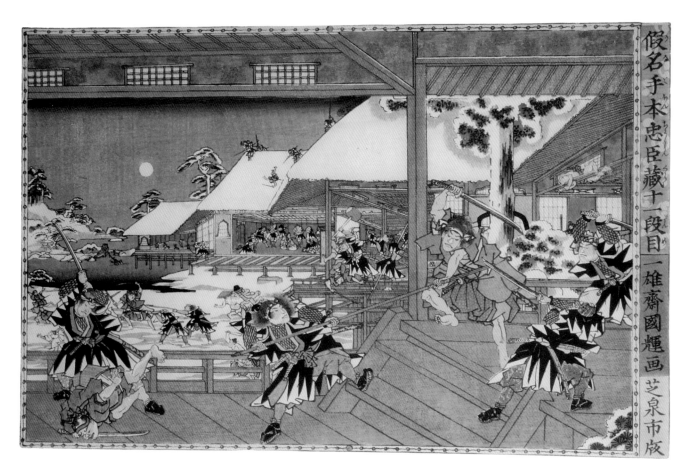

Act XI. One of Moronao's strong guards finally slain by the Ronin.

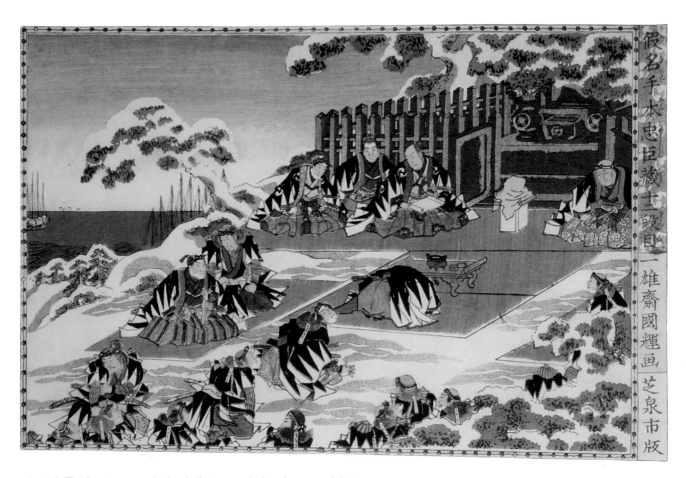

Act XI. The Ronin present the head of Moronao before the grave of their master.

Utagawa Kuniyoshi

1798–1861

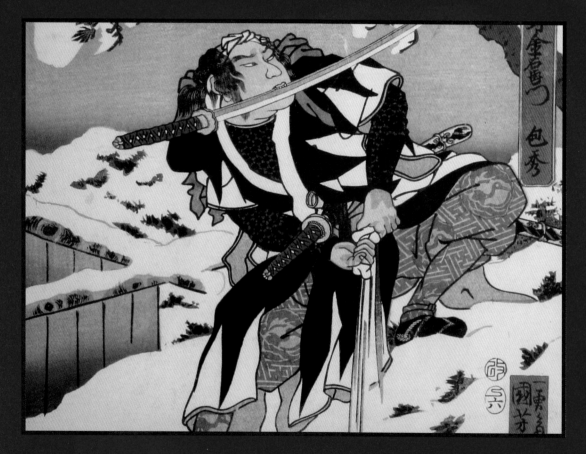

SERIES: STORIES OF THE TRUE LOYALTY OF THE FAITHFUL RETAINERS, WOODBLOCK PRINT
GIFT OF DR. AND MRS. MORRIS SHUMIATCHER, ART GALLERY OF GREATER VICTORIA

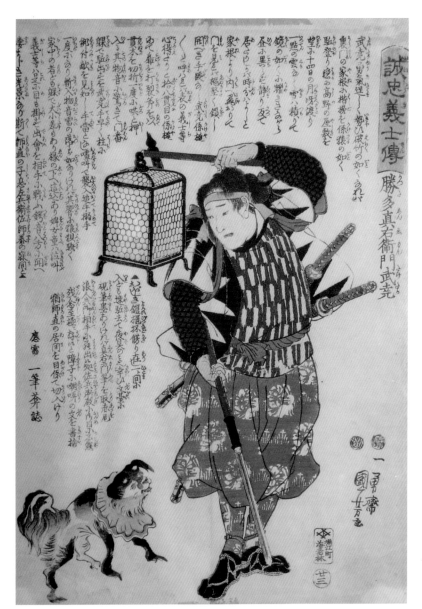

Katta Shinemon holding
a lantern beside a dog,
001.20.5.

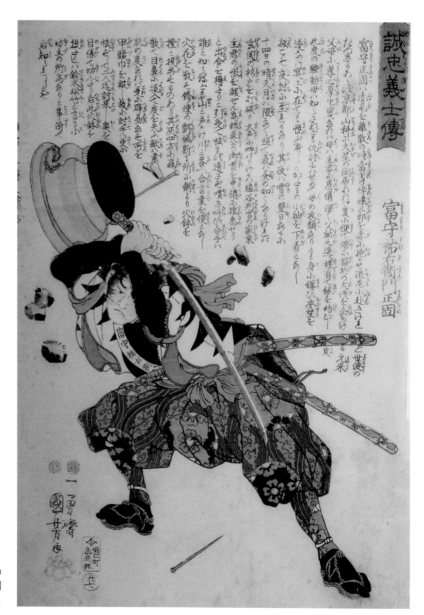

Tominomori Suke'emon Masakata ducking a charcoal brazier being thrown at him.

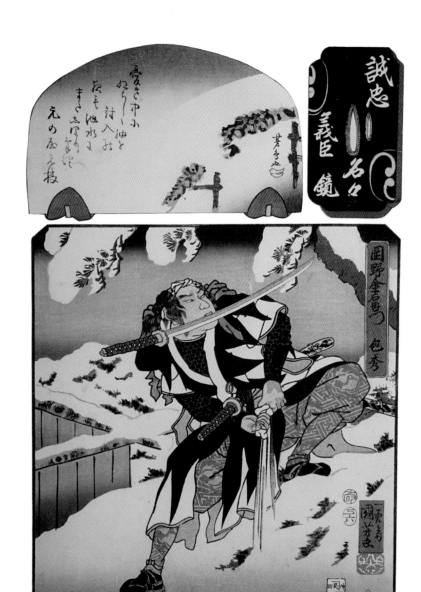

Kinemon Okano carrying
a sword in his teeth.
Intended gift.

Utagawa Kunisada

1786–1865

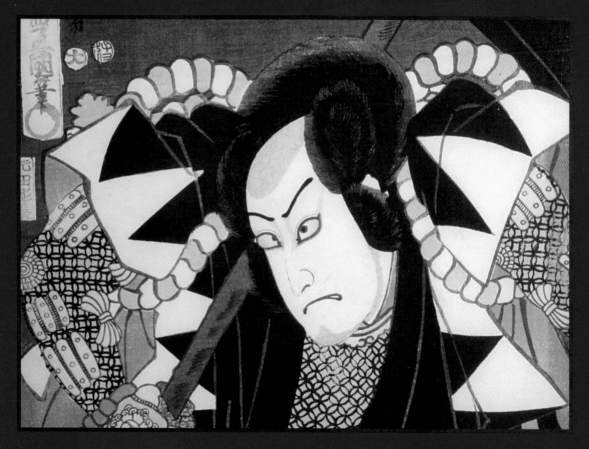

SERIES CHUSHINGURA, WOODBLOCK PRINT
GIFT OF DR. AND MRS. MORRIS SHUMIATCHER, ART GALLERY OF GREATER VICTORIA

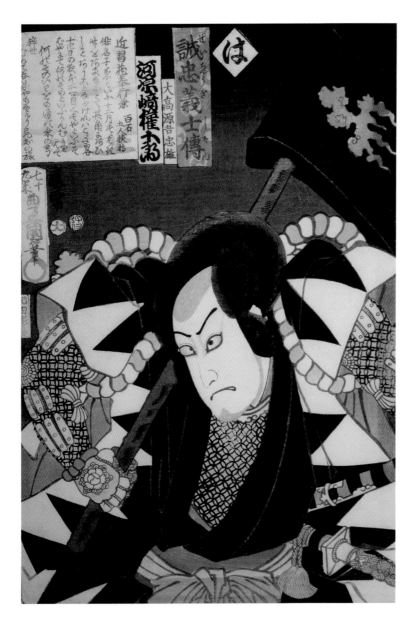

Kabuki actor as the Ronin,
Ataka Gengo Tadao,
carrying a large ax.

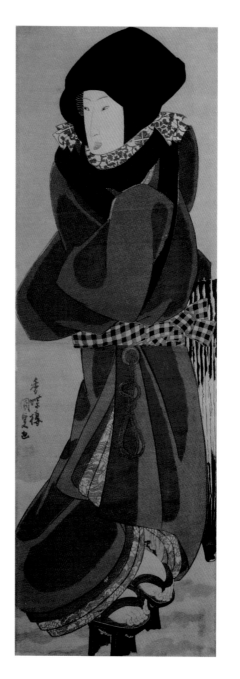

Osono, the divorced wife of the Ronin's
weapon supplier (see Act X), 001.20.11.